MILLET

1814 – 1875

BY PERCY MOOER TURNER

PLATE I.—THE WOOD-CUTTER
(In the Louvre)

An instance of Millet in a less pessimistic mood than we generally find him. The wood-cutter, pursuing his vocation on a warm sunny day, full of life and vigour, brings before us the joyous side of peasant life. We feel that he is happy and contented, and if his lot is somewhat hard, he has none of those distracting ambitions which mar the enjoyment in life to all who fall a prey to them. The wood in the background is a good example of Millet's powers in this direction.

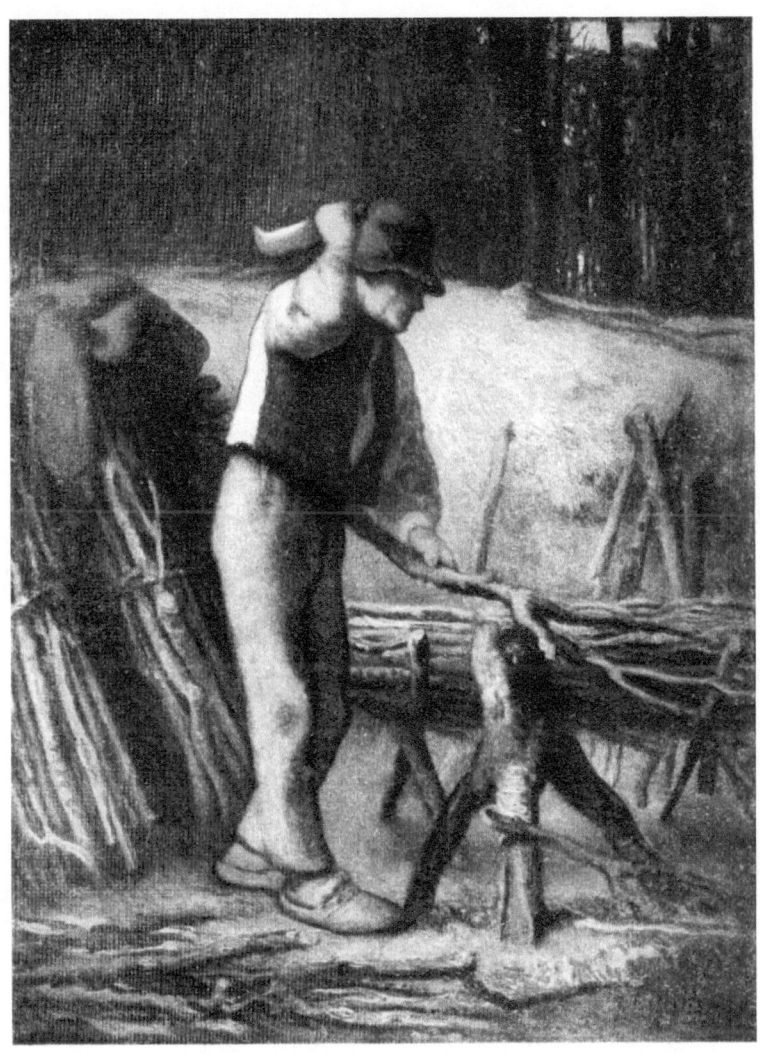

This book is an unabridged reprint of the first edition published by T. C. & E. C. Jack, London, and Frederick A. Stokes Co., New York, in 1910. Page numbers differ from the first edition.

Typeset and republished by Michael W. Gioffredi. Copyright 2019. MichaelGioffredi.com/vbeu

ISBN-13: 978-1-0778-7316-2
ISBN-10: 1-0778-7316-6

2 4 6 8 10 9 7 5 3 1

CONTENTS

Chap.		Page
I.	Introduction	7
II.	Millet's Early Life	21
III.	The Migration to Paris	31
IV.	The Struggle for Recognition	39
V.	Millet in his Maturity	43
VI.	The Man and his Art	54

LIST OF ILLUSTRATIONS

Plate		Page
I.	The Wood-Cutter	iii
II.	The Weed-burner	11
III.	The Church at Gréville	17
IV.	The Gleaners	25
V.	The Straw-binders	29
VI.	Spring	37
VII.	The Sawyers	47
VIII.	The Sheep-fold	53

I
Introduction

AMONGST the great painters of peasant life the name of Jean François Millet stands out prominently. A long interval elapsed betwixt the death of Adrian van Ostade and the birth of Millet, unbroken by a single name, with the solitary exception of Chardin, of a painter who grasped the profundity of peasant life. In Holland and Flanders in the sixteenth and seventeenth centuries we find many painters who, whilst living the humblest lives themselves, saw in their surroundings such material for treatment as has handed their names down to posterity. It is only quite recently that one of the greatest of all, Pieter Brueghel the Elder, has come to occupy his proper position in the world of art. Formerly he was looked upon as an eccentric painter, whose subjects were generally of rather a coarse nature; who, moreover, contented himself with depicting the droller side of the village life of his period, and consequently was not to be taken seriously. Of late years, however, an exhaustive research into his life and works have revealed him as one of the greatest masters in his own sphere of any time. The wonderful series of pictures in Vienna, and

the solitary examples scattered about the great collections of Europe, proclaim him not only a painter, but a philosopher as well. His peasants, grotesque as they may now appear to us, possess a fidelity and vigour of handling such as none of his contemporaries possess. To him, consequently, we must look as the fountain-head of all peasant painting. His influence was immediately felt in the Low Countries, and there sprang up that wonderful school of which Adrian Brouwer, Jan Steen, and Adrian van Ostade are such brilliant exponents. In their more recent prototype—Millet—the same profound and sympathetic rendering of the everyday life of the simple peasant is to be found, tinged with the melancholy fervour of his temperament. Their temperament bears the same relation to his as the seventeenth century does to the nineteenth. A more subdued temper had come over all classes of the community, a less boisterous attitude towards life, but the struggle for existence was none the less strenuous or unending. The rollicking and reckless joy of Brouwer's peasants, with their hard drinking and lusty bawling, was an essential feature of Dutch life of the period. But they are every whit as precious from an artistic and historical standpoint as are the placid interiors of Millet.

During the two centuries which elapsed between these great masters many changes had come over the lives of European people. The spread of education, permeating down even to the lowest classes, had tended to the sobering of habits; and the French peasant, with the partial uplifting and greater contact through more equitable distribution of the land which the Revolution had bestowed upon him, was a quieter man than his Dutch prototype who had preceded him by a couple of centuries.

In Millet's rendering of the life he found around him, the

same incisive truth and absorbing sincerity is to be found as in the Dutchmen with whom I have compared him, and consequently Millet can be considered as a direct lineal descendant of the mighty Brueghel.

The entire absence of the Dutchmen's brutality in Millet's work is to be accounted for, firstly, by the extreme gentleness of his own disposition; and, secondly, by his study of some of the greatest masters of the Italian renaissance. His keenness of perception can be gauged by his enthusiastic appreciation of Andrea Mantegna at a time when the merits of that master were not understood as they are to-day. Many of his noblest inspirations were conceived under the Paduan painter's influence, and one could cite many compositions in which the train of thought of the two masters seems to run upon parallel lines.

Upon first regarding a picture of Millet's mature years, one wonders from whence come those subtleties of line and tone. There is nothing analogous to them in the works of his contemporaries. The difference too between his early efforts and those of his later years is stupendous, but the lines which his development pursued are essentially due to the simplicity of the life he led and the high ideal he invariably kept before him. Living, as he always did, a life of struggle, a never-ending battle against seemingly overwhelming odds, he was in a position to grasp the sorrows and troubles of the simple folk by whom he was surrounded. He further saw that work, although they themselves were not aware of it, alone made life liveable to them. He shared their struggles in their most intense and poignant form. In fact when one contemplates the life which Millet led, both at Gréville and at Barbizon, with its strenuousness and earnestness, faced, moreover, with the ever-present dread of want, it is to be wondered that he had the courage to live his

PLATE II.—THE WEED-BURNER
(In the Louvre)

A notable example of the simplicity of motive which characterises Millet's finest works. The treatment of the peasant figure in the centre of the picture is dominated by sincerity and sympathy. The half suggested landscape forming the background is symbolical of man's hard struggle with Nature. The colour scheme is very subdued, and serves to accentuate the wonderful outline and natural pose of the woman.

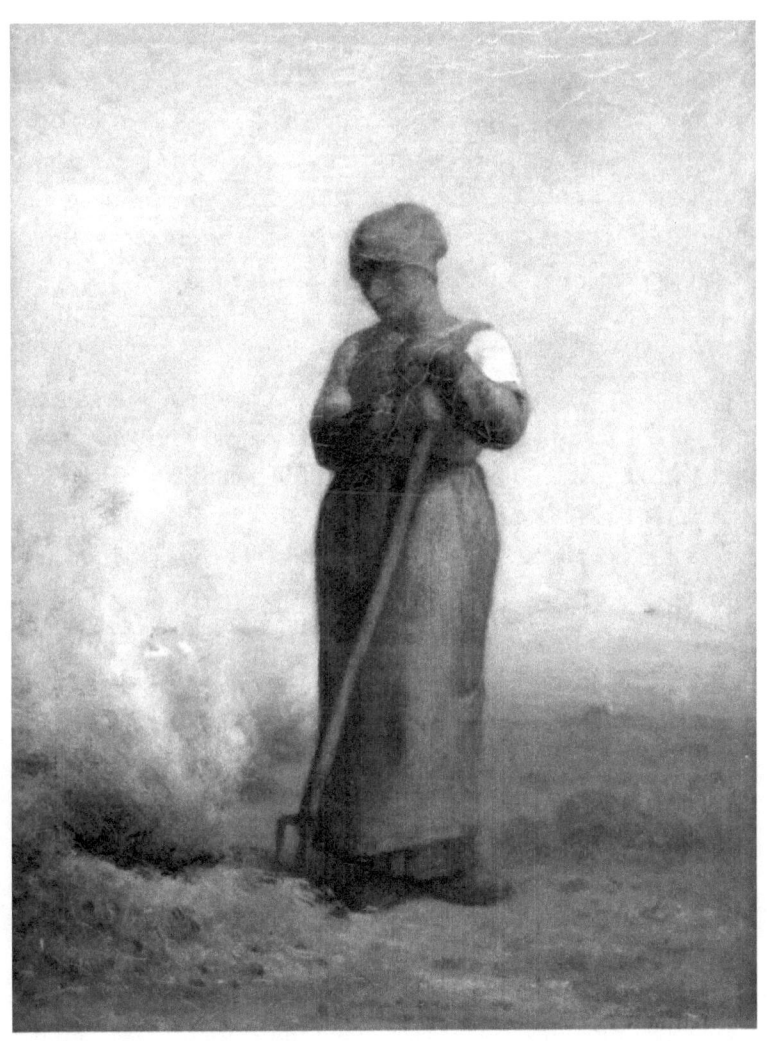

life as he did.

It has become the fashion lately to decry certain phases of his art. A charge of sentimentality is urged against some of his most popular works. The "Angelus," about which many hard things have lately been said, is a case in point. It must be remembered that modern life, particularly as lived in great cities such as London or Paris, does not tend to foster those simple ideas upon religion, which the peasant, far removed from great centres of population, implicitly accepts. He is, as a rule, a man of but little education, who has heard nothing of the doubts and scepticisms with which townspeople of every grade of society are so familiar. His ideas on religion are exactly those which have come to him from his parents, and he is incapable of doubting the elementary truths he was first taught. Such simple ideas have departed from even the peasantry in most parts of France. Only in Brittany and in La Vendée could one to-day encounter the types Millet has portrayed for us in the "Angelus."

The two figures in the foreground are symbolical of all that is most touching in French peasant life. The end of the day has arrived, and after many hours of unremitting toil, the ringing of the bell in the distant tower proclaims the finish of another day. The wonderful still atmosphere which envelops the far-stretching plain, the whole suffused with the effects of a placid and glorious sunset, lends an intensity of poetical feeling which harmoniously blends with the placid nature of the theme. All around us we have evidence of man's perpetual struggle with nature, the grim fight for subsistence, for life itself. The ploughed field has yielded many a crop, the reward of arduous labour expended in sowing and reaping. The small recompense to the labourer himself is symbolised by the ex-

treme poverty with which the man and woman are clothed, whilst the degrading nature of the toil, as in the far famous "Man with the Hoe," is brought before us in the rugged types of the labourer and his wife. The only softening influence in their lives is that imparted by religion, and in choosing this moment of the angelus for depicting them, Millet has brought before us in the most forcible form not only the degrading character of much of the toil which is entailed in producing the necessities of existence, but also the danger of removing by any sudden change, no matter how well intentioned, the consoling influence of religious belief. A work into which such intense earnestness and melancholy truth is infused can never be designated sentimental, except by those who have not freely grasped the immense import of these qualities in the production of great and enduring art. Brilliancy of technique and extraordinary facilities, if unsupported by a determination to convey some message, will inevitably find its own level, whilst the painter who possesses this supreme quality will assuredly come into his own.

It must never be forgotten that in considering the oil paintings of Millet, the subtleties of atmosphere and line can never be appreciated if one is not acquainted with the country he painted. No two countries are alike in atmospheric effect, and it is necessary, therefore, in order to appreciate an artist to the full, to have studied the country he has chosen to depict. The outlines of the landscape, the very shape of the trees, the colour imparted by sunshine and clouds, differ materially in various districts, and consequently it behoves one to exercise caution before condemning this or that effect as being untrue to nature.

It may safely be said that as a painter, purely and simply,

Millet will never occupy a very high position in the world of art. He never bursts forth into any of those pyrotechnics which distinguished many of his contemporaries and some of the painters of our own days. His manner of handling the brush is always restrained to the point of timidity. By this I do not mean to imply that he could not paint in a large and bold manner; indeed on many occasions, as for example in the "Sawyers," he has attained an astonishing degree of power. But as his whole thoughts were directed to suppressing any tendencies towards virtuosity, which might divert attention from the point he wished to illustrate, he frequently appears to achieve his ends by holding himself in restraint.

Another dominant characteristic of Millet's art is that the instant he throws off his sadly philosophic mood, he is no longer a great artist. For example, in the well-known picture of "La Baigneuse," he endeavours to draw himself into depicting the brighter side of life. In a wood resplendent with the sunlit foliage of a glorious summer day, a young girl is about to enter the small river which runs placidly between the moss-covered banks. In the distance a number of ducks are disporting themselves in the water. Here is a theme which would appeal irresistibly to a man of the temperament of Diaz; he could impart the glories of colour as they were reflected from the mirror-like surface of the water, the shimmering of the trees and the delicious effect of the balmy breeze as it rustled through the branches. But in the hands of Millet it is nothing but a sad composition; the figure is well drawn; the ducks are admirably placed in the composition, and the trees treated with studious fidelity, but there is that great indefinable something lacking which attracts us towards the master when working in a sadder mood.

MILLET

Millet can be described as being more a philosopher than a painter. Not only in his great paintings, which by the way are not very numerous, but in his drawings and etchings, we discover the mind of a man who has grappled with, and understood the great problems of life. Poor as he was, and remained all his life, it is doubtful whether riches or an improvement in circumstances would have brought him any increased happiness. He loved the open country, and still more the solitary peasant whom he found working in the fields, earning a bare subsistence for himself and his little ménage in the neighbouring village. His interest was divided between the man at his work and his wife and children in the *ménage*. The simplest incidents of their everyday life did not escape him, and the smallest duty which would have left unaffected a less observant nature has been made the subject of many a fine canvas.

One of the subtlest landscapes by Millet in existence. It shows that on occasions he could leave the beaten track and still remain as great a master as ever. Everybody who knows the atmosphere of Normandy will appreciate its truth and poetry. The marvellous results he has achieved with such a simple theme is worthy of our praise. The whole effect is so natural that we are apt to forget the keen sense of composition that was needed to present the subject in such an attractive form.

Millet seems particularly to have been impressed with the loneliness of the peasant's labour. Take, for example, that wonderfully luminous canvas, "The Sheep Pen." Here, in the midst of a vast plain, a large space is marked out in which to enclose the sheep for the night. The sun, sinking low in the horizon, warns the shepherd that the time has arrived for him to call together his flock and place them in safe quarters for

PLATE III.—THE CHURCH AT GRÉVILLE
(In the Louvre)

One of the subtlest landscapes by Millet in existence. It shows that on occasions he could leave the beaten track and still remain as great a master as ever. Everybody who knows the atmosphere of Normandy will appreciate its truth and poetry. The marvellous results he has achieved with such a simple theme is worthy of our praise. The whole effect is so natural that we are apt to forget the keen sense of composition that was needed to present the subject in such an attractive form.

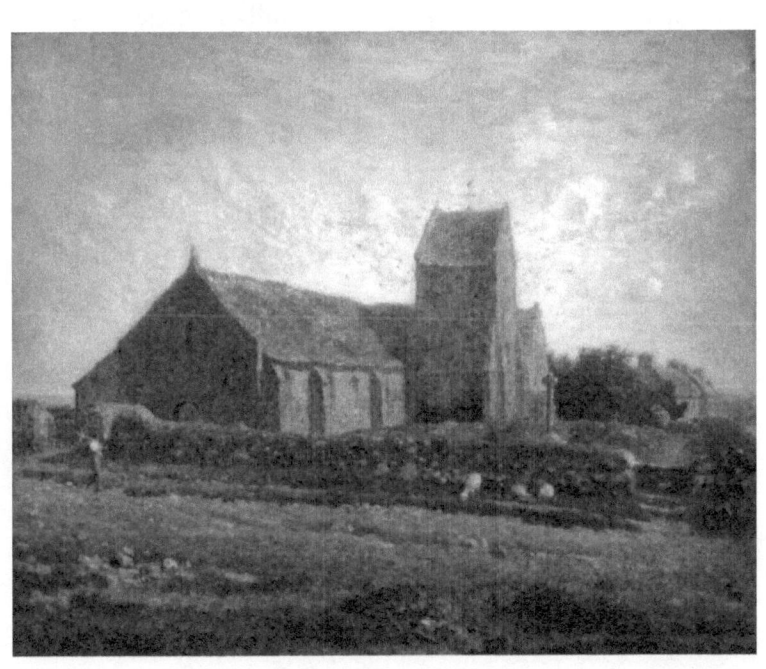

the night. Accompanied by his faithful dog, he stands at the opening of the pen allowing the sheep to enter two or three at a time. There is no other living soul in sight. Alone he has kept guard over the flock during the long day, with no other company than his dog and his own thoughts. He is dead to the beauties of the landscape around him, and sees nothing more in a field than how much corn can be raised each year from it, or in the sheep he tends so carefully how much mutton it will make. He feels nothing of the glorious beauties of the sunset, of which he is so often a witness; how it softens the lines of the horizon and suffuses the distant woods and plain with its golden rays. He sees nothing of the changes momentarily occurring in the sky: how the blues get fainter and fainter, how the clouds are tinged with opalescent hues, the shadows prolonging themselves as the orb sinks deeper and deeper; or how, finally, when the sun has disappeared, the whole heavens are lighted up in one blaze of glory. Yet Millet would have us understand that in spite of this, the shepherd is performing a duty to humanity not to be underrated. The sheep he has so carefully and conscientiously reared will form food to-morrow for many a hungry town-dweller. Further, he would have us follow the peasant as he closes the pen for the night and traces his tired steps towards his simple home in the village. The frugal and hard-earned meal, prepared for him by his wife, who like himself has had her share of duties to occupy her during the day, is partaken of surrounded by a hungry and joyous group of children. Such themes suggested by the simplicity of his own life appealed to him with irresistible force, and it is in their portrayal that his greatness is manifested.

Perhaps no season of the year presented the same attraction for Millet as the spring. The period when all the earth after its

long winter sleep is about to waken into new life seems to have always been a source of inspiration to him. In "The Sower" he emphasises the fact that the fruits of the harvest are not to be had without due labour being expended upon the earth. The sloping field, barren of vegetation, and crowned at the top with a small clump of trees, is being broken up by the distant plough drawn by two horses and guided by a peasant. The latter figure is one of the noblest of Millet's creations. By his strained and ever-attentive attitude, by his continuous tramp over the rough and broken ground, he shows us the monotony of his toil. He crosses the field in one direction, only to return at an interval of a few feet. In the foreground we have the sower, a middle-aged man of typical peasant type, on whose left side a bag of seeds is slung. With automatic precision he withdraws a handful, and strews it into the furrows open to receive it. So long as he continues in the same track his labour will be well performed, and hence his task is just as monotonous as that of his fellow-worker higher up in the field. The silhouetting of these two figures against the light is symbolical of the labour to be expended in life before results are forthcoming.

From these remarks it will be seen that in considering the works of Millet, one must not judge him from the standpoint of a mere painter. His brush is only the means to an end, and by its means he is enabled to bring the fruits of his philosophic observation before us in permanent form. It has been charged against the "Angelus" that it was not a remarkably fine piece of painting, that many a young artist of the present generation is infinitely better equipped, technically speaking, than the master who wrought this celebrated canvas. This may in a measure be true, but it must never be forgotten that Millet brought into play exactly the means which could illustrate his

meaning in the clearest terms. He had not intended, in painting such a picture, to produce a work which would astonish his fellow artists with its brilliancy of handling or magnificence of colour. He wanted to make the beholder forget the painter and absorb the lesson. This quality runs right through the art of Millet, and it is from this standpoint that we are obliged to weigh his merits.

II

Millet's Early Life

JEAN François Millet was born on October 4, 1814, that is at the period when French art, at any rate as far as landscape painting is concerned, had reached its lowest ebb. Throughout the eighteenth century the landscape painter had been hard put to make a living. The taste of connoisseurs throughout the century had been for portraits and interiors, or for those numerous pastoral subjects which were carried out with so much decorative charm by such men as Watteau and Boucher. Such landscape painting as existed was of the type popularised by Vernet; it was built upon a curious mixture of Italian influence coming from Panini and Salvator Rosa. The only evidence of revolt against such a state of affairs we find in the works of Hubert Robert and Moreau. These two, and more especially would I direct the reader's attention to the latter, struggled hard to break down the conventionalities of the time. They endeavoured to infuse some sense of atmosphere into their pictures, and whilst frequently their trees and figures are painfully formal, they yet stand alone in the French school as the pioneers of a phase of art which was to attain its zenith in the middle of the nineteenth century.

But after the Revolution, and during the whole of the time that France was under the domination of Napoleon, very rigid principles indeed were enforced with regard to the direction that art should take. The innovation which had its commencement in the reign of Louis XVI. swept everything before it as it

gained force. Classical art and traditions dominated the whole French school, and no artist, however great his reputation, attempted for many years to swim against the stream. In spite of the principles of liberty and equality which were claimed for all under the new *régime,* a terribly strict eye was kept upon any innovations which might break out in the form of a naturalistic art. The directors of this new movement failed to see that the conditions which had produced the great Greek and Roman sculptors had passed away, and that the latter's supremacy was due to the fact that their productions were symbolical of the loftiest thoughts of their own epoch. The art which expresses the ambitions and noblest thoughts of its time will alone endure. These expressions are not applicable to any other condition than those which called them forth, and hence in attempting to purify the rococo which had existed up to the middle of the eighteenth century, by a return to classical traditions, they were only copying that which their predecessors had done, and in so doing left us without any original expression of their own time.

Into such a condition of affairs was Millet born, and he was numbered amongst that little band of men which included Rousseau, Corot, Dupré, Diaz, and Daumier, who were to lay the foundations of the modern naturalistic school. At the outset it was seemingly a hopeless struggle they undertook; a struggle against prejudice and influence which was only to be brought to a victorious culmination after years of struggle and disappointment. Of this little band, Millet was perhaps the best equipped for the privations which were necessary. He came of a peasant stock who inhabited Gruchy, a small village situated in the commune of Gréville, close to Cherbourg. Grouped underneath the humble roof was the grandmother,

who had been left a widow fifteen years before; her son, Jean Louis Nicolas Millet, and his wife and eight children, of which our artist was the second. His grandmother appears to have been a pious old lady, whose chief delight was in her grandchildren, to whom she taught those religious principles which stood them in good stead in after life. We are told that Millet's father possessed a force of character one does not often find amongst men in his rank of life. He was of a contemplative disposition, and had a keenly developed feeling for natural beauty. He possessed moreover a keen appreciation of music, which unfortunately he does not appear to have had much opportunity of cultivating. His wife was an excellent housewife and of a religious turn of mind. The house they occupied, situated quite a short distance from the sea, was placed in a tract of country which, whilst it had rugged and picturesque features, was not of a nature which would yield extraordinary results under cultivation. It was, therefore, a hard struggle for existence which Millet in his first years saw going on around him. Not that the family were any the less happy for having to work laboriously for their livelihood. They had been brought up amidst such surroundings; their wants were simple and easily gratified, and the tranquillity of the *ménage* more than counterbalanced those doubtful luxuries which easier circumstances would have brought their way. Throughout his life Millet maintained the extreme simplicity he had seen practised in the home of his childhood, and long years afterwards he was accustomed to look back with pleasureable memories upon his early years.

Gruchy, situated in one of the wildest parts of Normandy, feels the full effect of every storm which blows up from the Atlantic. There is nothing to shelter the exposed hamlets studded along the coast from the fury of the western gale, and

PLATE IV.—THE GLEANERS
(In the Louvre)

One of the most popular pictures of the master, and by many considered his masterpiece. We know that this work involved an unusually large amount of thought and work on the part of the artist. Separate studies exist of all the figures in many different poses. Not the least wonderful part is the background, with its crowd of harvesters, enveloped in the golden sunlight of a warm summer afternoon. "The Gleaners" is one of the best preserved of the large canvases of Millet.

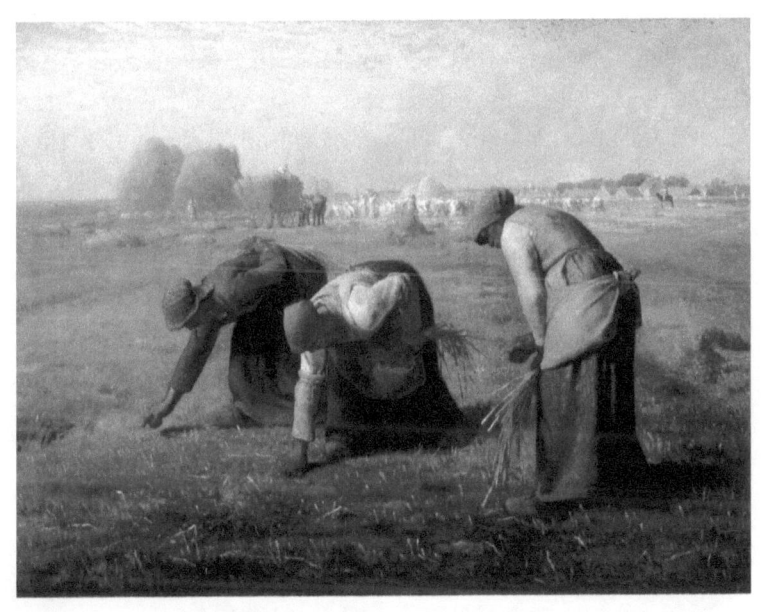

the rocks are but too often strewn with the wrecks of vessels which have come to grief in that terrible sea. Millet in his youth must have witnessed many of these catastrophes. Quite a number of drawings by him are extant representing succour being extended to some vessel in difficulties, or the hauling up of some wreckage on to the rocks. The studious boy must have been impressed as he saw the sternness of the combat in his native country between men and nature; the wind-swept fields, and hills bare to the point of savageness. The very trees themselves dwarfed and gnarled; in their struggle with the elements they have been made tough and hardy as the inhabitants of the country themselves, and, stunted as they are, yet show well that they can resist the force of the fiercest storm. The brooding and contemplative character of the father having descended to the son, we can quite imagine the effect such surroundings would have upon him. As he looked back in after years upon his roamings in his native country, he appreciated the awe-inspiring character of the scenery in which he had been born. He would doubtless recall many a walk amidst the fields with the wind blowing in his face as it rushed in from the Atlantic, the rain beating hard upon the freshly ploughed fields, and the distant figure of the ploughman struggling hard with his team against the stiff sou'wester. The great mass of vapour overhead whirled before the violence of the storm, casting grey and pearly light over the whole scene, whilst far away on the top of the hill a clump of trees, bent with their resistance to the wind, are silhouetted against the sky. Many a drawing of this kind we encounter in the later work of Millet, which shows how his thoughts harked back in certain moments to the scenes he had left behind him for ever.

We know that on one or two occasions he returned to

Gruchy. Once or twice he had urgent business which took him back, but sometimes he went with no other purpose than to renew acquaintance with the scenes of yore.

Little Jean François was his grandmother's favourite. It was she who taught him the names of things which surrounded him, and perhaps directed his thoughts in the channels to which they were finally to be devoted. Her brother Charles, who formed one of the family, used to take him for walks, telling him stories on the way. Millet was devotedly attached to this old man, and when at the age of seven years he lost him, the gap in his life thus left made an impression upon his memory never to be effaced.

Five years afterwards he was placed in the hands of the vicar for the purpose of preparing him for his first communion. The good man seems to have been taken with the child; he found him so attentive to all natural phenomenon which was passing around him and intelligent in an unusual degree. He quickly learnt a considerable amount of Latin, which introduced him to the great classics. Unfortunately for Millet, the vicar accepted an offer of transference to a better parish in the vicinity. The boy had made such progress with his master that it was decided that he should go with him to his new abode. He was, however, so missed in his own home, that when he came back for his first holidays it was decided that he should not return.

He now gave serious attention to the agricultural pursuits of his father. He threw himself heartily into the work of the farm, and assisted in the work of sowing and harvesting, of pruning and thrashing according to the season. His spare time was occupied in reading with avidity various masterpieces of literature. The authors he found at hand were such as Fénélon

PLATE V.—THE STRAW-BINDERS
(In the Louvre)

The wonderful capacity of Millet for portraying action is demonstrated to the full in this canvas. Hard, unremitting toil is the theme Millet has wished to bring before us. The heat is intense, but the work goes on with unrelaxing vigour. The masculine energy of the two bending figures are in striking contrast with the figure of the young girl on the left of the picture. The artist shows that he was quite capable of infusing charm into his peasant studies as well as bringing the brutalising aspect of their labour before the spectator.

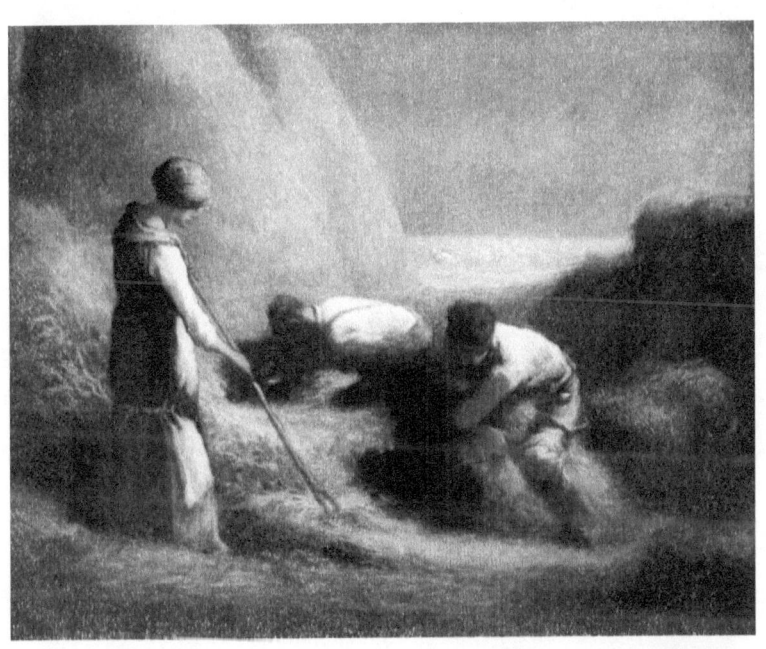

and Bossuet, but he developed a decided preference, which lasted till the end of his life, for Virgil and the Bible.

It was at this time that his taste for art began to be developed. He drew the objects he found around him, and soon acquired sufficient confidence in his skill to execute a large drawing representing two shepherds keeping guard over their sheep. These first efforts date from about his seventeenth year, and foretell the advent of the style in which he was later to become pre-eminent.

III

The Migration to Paris

HOW frequently has it happened that the first years in the life of a genius have been employed in labour quite different from that to which they should have been directed. Such a state of affairs the more often occurs when the sense of duty has been strong enough to overcome temporarily the inclination to pursue the natural bent. In the case of Millet, however, the early years which he devoted to the farm and its pursuits were by no means wasted. It is on record that he became very proficient in the various duties in which he was engaged, but at the same time we can be quite sure that his extraordinary faculties of observation were constantly being brought into play, and the fruits of his observations are to be seen in the pictures of his mature period.

A considerable portion of his spare time was taken up with drawing, not only the persons and objects he found around him, but also subjects suggested to him by the books he was in the habit of reading. His family, so far from throwing any obstacles in his way, encouraged him. In fact it was his father who took him first to Cherbourg in order to show a painter of that town, named Mouchel, the early products of his son's genius. The decision at which Millet père had arrived was prompted by a drawing in charcoal of an old peasant walking along the road, which had struck him forcibly as being a work of extraordinary merit. It says much for Mouchel's breadth of mind that he was equally impressed with the drawings. A man

who had been brought up in the school of David, and who had lived in one of the most reactionary periods of French art, was hardly to be expected to take kindly to a style so diametrically opposed to all the traditions into which he himself had been inculcated; certainly the young Millet, who had now arrived at the age of eighteen, had not developed the extraordinary freedom which his works of ten years later demonstrate. But there was sufficient originality even in his early drawings to call forth condemnation from a man who had been so saturated with the teaching of David.

He prevailed upon Millet to leave his son with him, and set him to work to copy many well-known works of art which he brought before his pupil by means of engravings. Two months were spent in this way when news reached Millet that his father had been seized with sudden illness, and he was obliged in the circumstances to return to Gréville. He arrived to find the old man unconscious, and very shortly afterwards he died.

This misfortune awoke in Millet a sense of duty which compelled him to desert his studies in Cherbourg and superintend the management of the farm. For some time he devoted himself entirely to his new duties, but the struggle betwixt duty and genius continued; he gave himself to his work with all the energy at his disposal, but his thoughts were ever wandering to his art.

Added to his own inclinations, his grandmother, who perceived his extraordinary gifts, strongly persuaded him to devote his attention entirely to art, and consequently after some little time he decided to return to Cherbourg. Here he entered the studio of M. Langlois, an artist whose reputation in the town was considerable. Again in this worthy man he came in contact with a painter who had been brought up entirely under

classical influence. Langlois, who had in his early days been a pupil of Gros, had absorbed the classical tradition to such an extent as to be incapable of appreciating any other style. He appears to have endeavoured to mould Millet in his own method rather than develop the latent genius which the latter possessed. The incompatibility of these two men speedily caused the younger to strike out in his own way. He saw more good in frequenting the museums and making copies of such works as appealed to him than in listening to the advice of his teacher. All this occurred, however, without any breach of friendship occurring. On the contrary, Langlois, after perceiving the futility of inducing his pupil to follow in his footsteps, did all he could to advance his interests.

By means of his influence some of Millet's drawings were brought before the Municipal Council, and Langlois suggested that Millet should be sent to Paris in order to further his development, and that the Council should set aside a modest pension to meet his requirements in that city. The discussion appears to have been very prolonged, and upon the question being put to a vote it was only carried by means of the casting vote of the mayor. Four hundred francs was at first allotted to him in this way, which was further increased shortly afterwards to six hundred. Such encouragement, meagre though it was, was sufficient to give him a foothold in the metropolis. He left Cherbourg in January 1837, on a cold and raw day, the snow falling heavily throughout the entire journey, and arrived in Paris in a very disheartened condition. The miserable weather, coupled with the long journey in which he had had time to think of the small sum which lay between him and starvation, going to a city which he had never seen before, had all served to work upon his nerves, and he entered the great city sick at

heart and very despondent.

One of the first visits he made after he was somewhat settled down in Paris was to the Louvre. Here he was brought into contact for the first time with many masters, who were to mould his yet plastic temperament into the form which enabled him to give to the world, in later years, so many masterpieces. As I have said before, it was Mantegna who first captivated him, and the influence of the mighty Paduan was never finally to be shaken off. Michel Angelo awed him with his sublimity; his classical severity tempered with intense humanism, his masculine strength, were bound to have their effect upon so serious a character as Millet. Strange as it may seem to those who are but superficially acquainted with his art, and are only too apt to judge him by the influence he has had upon modern French painting, he was fascinated with the antique. The traditions of Phidias and Praxiteles, in the form in which they had been transmitted through the greatest minds of the Renaissance, were ever the factors which guided him throughout his career. It was this same spirit which impelled his fervid admiration for Nicolas Poussin, a master who to-day is sadly underrated and but little understood. It was the mysteries of line, the wonders of pose and composition rather than the magic of colour which appealed to him. He had a profound admiration for the glowing canvases of Titian and Rubens, but he could never overlook entirely their defects of drawing or, in the case of Rubens, the tendency to vulgarity. From his remarks in after years it would appear that he was baffled with the mysticisms of Velazquez and Rembrandt; pure painting itself could never hold him. He needed to grasp the message which lay behind it before he felt fully taken into the confidence of the painter; and as the minds of the Dutchman

and the Spaniard ran in quite different channels to his own, they spoke with a language he never understood. That he had a perceptive and critically independent mind may be gauged from his enthusiasm for Delacroix, whose work he encountered for the first time at the Luxembourg.

During this period of study he was carefully considering under what master he should place himself. His choice unhappily fell upon Delaroche. To any one acquainted with the work of the latter master, a more unsuitable selection could not have been made. Delaroche and the painters who surrounded him can be appropriately described as constituting the back-wash of the Empire style, which had reached its climax with David. His subjects were always treated with academic reserve. No pyrotechnics were permitted; on the contrary, an everlasting and mistaken striving for finish was encouraged: originality was sternly suppressed. To paint human life as it really was, was too vulgar for any of the painters of this time. They held the public taste enslaved for years. An innovator such as Millet was destined to become found his position almost untenable. The band of critics and painters formed a monopoly which it seemed almost impossible to break down, and it was only after years of bitter and determined struggle that the school of nature finally routed its opponent.

Delaroche doubtlessly found the peasant painter a little rude both in his person and in his ideas about art. He paid but little attention to the young man who had placed himself in his hands, and devoted all his time to students who were more amenable to his influence. A temperament so sensitive as Millet's was bound to notice this neglect, and consequently after a time he became so discouraged that he ceased to frequent Delaroche's studio. Another very good reason for this action was

PLATE VI.—SPRING
(In the Louvre)

It is probable that Millet wished this picture to be regarded rather as a symbolical representation of Spring, than as an actual study from Nature. The storm that has just passed over has been severe, but of short duration. The sun, breaking through the dense banks of clouds, reveals the splendours of the water-sodden landscape; the apple-trees full of bloom, the verdantly green grass, the young foliage on the distant trees, all reveal the benefit they have received from the downpour.

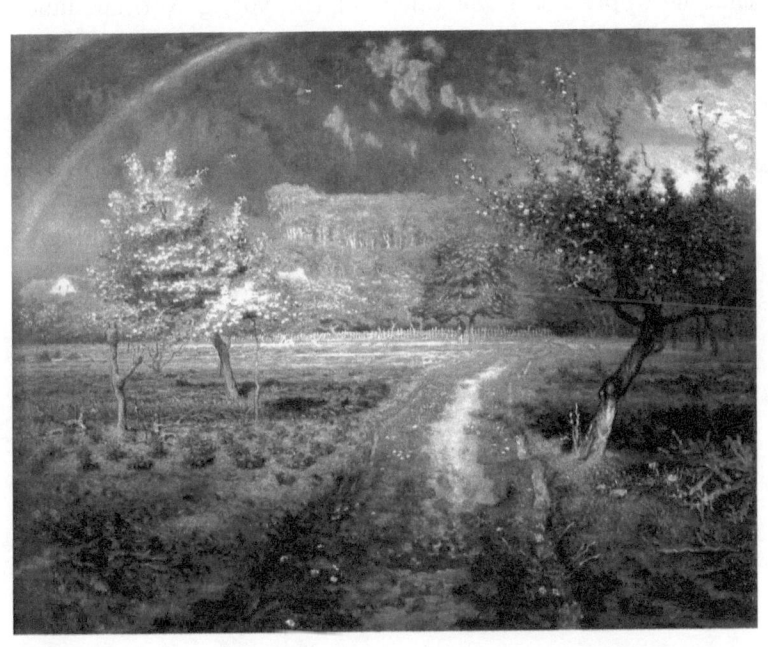

the lack of resources to continue his payments. Even during the time he had been with Delaroche he lost no opportunity of turning a few honest francs by painting the portraits of any who could be got to sit to him. Delaroche, however, had a more kindly heart than Millet imagined. He seems to have found out the real distress of the young artist, and to have assisted him pecuniarily in many ways, and there is no doubt that he appreciated the talent of the young Norman much more than he cared to own. Many of his remarks on record would serve to show that Delaroche already felt that his pupil was destined to be one of the leaders of the movement which was finally to overthrow his own style, and doubtlessly felt a great admiration for a man who had the courage and strength to swim against rather than with the current.

IV

The Struggle for Recognition

FREED from all encumbrances save poverty, Millet was now to work out his own destiny according to the dictates of his genius. He joined a friend named Marolle, and the two together occupying a very small apartment endeavoured to eke out an existence. It was only too soon apparent that young as he was, and the taste of the public being not yet ready for development upon the lines his genius directed him, that his livelihood could not be secured by endeavouring to sell such subjects as appealed to him. In these straits he turned to portrait-painting, just as many great painters before and since him have done. That the struggle was very keen can well be imagined by the fact that he was unable to obtain more than five to ten francs apiece; and, as commissions were very scarce, he was hard put to gain the means of subsistence. This state of affairs lasted until 1840, in which year he endeavoured to obtain admission to the Salon with two portraits, one of which was that of his friend. This, however, was rejected, and the other picture, although accepted, was unnoticed by either the critics or the public.

Having occasion the next year to pay a visit to Cherbourg, he felt obliged to report himself to the Municipal Council who had had the generosity to send him in the first place to Paris. Its worthy members expressed themselves as but little satisfied with the result of their investment; they claimed that they had had as yet but little to show for their money, and they sug-

gested, partly as a means of demonstrating that they had had some little return, and also, in order to see of what stuff their *protégé* was made, that he should paint a portrait of the recently deceased mayor. As Millet had not been personally acquainted with that worthy citizen, and as the only guide which could be supplied him was a portrait made in miniature when he was a young man of some twenty-three or twenty-four years of age, the task was by no means easy. However, the artist set to work with a will, and finally accomplished the picture to his own satisfaction. Upon it being shown to the Council, one and all declared, as any one with the slightest knowledge of such matters could have told them before it was commenced, that it bore not the least resemblance to the defunct magistrate. They therefore demurred at the three hundred francs they had agreed to pay him for the portrait, and offered him one-third of that amount instead. Millet was deeply offended by the insult, and informed the Council that he made them a present of the picture.

It was during this short visit to his native country that he met his first wife, a Mlle. Ono, whose portrait he had painted. From the first she was very delicate, and he lost her after much suffering, three years later. His second wife was Mlle. Catherine Lemaire, who was destined to be the companion of his struggles until the end of his life.

Meanwhile Millet was occupied with subjects which he thought would appeal to the general public. A number of classical pictures date from this epoch. It was an endeavour on his part to fall in as far as possible with the current taste, and so supply means of subsistence for his family. At the same time he did not neglect his favourite subjects, and many are the wonderful studies of peasant life which date from these

years. His reputation had so far advanced that he was offered the position of teacher of drawing in the college at Cherbourg. It must have been only after prolonged deliberation that he refused the proffered post. Here a certain annual stipend was assured him, and if it was not large in itself it would at any rate suffice to keep the wolf from the door. He preferred, however, to return to Paris and work out his own destiny as best he might.

Millet, who lived at this time in the Rue Rochechouart, began to surround himself with that little group of friends who remained faithful to him until the end of his career. Amongst the earliest were Charles Jacque and Diaz: the latter had several clients amongst the small dealers, whom he induced to visit Millet's studio and make now and again a small purchase.

Millet now became a fairly regular contributor to the Salon, but generally sent some classical or religious picture as well as one of his peasant subjects. For example, in 1848 he sent the marvellous study of "The Winnower," which we all know so well, accompanied by a canvas, "The Captivity of the Jews at Babylon." The latter, however, was so badly received that he utilised the canvas upon its return for a large picture of a "Shepherdess tending her Sheep."

In spite of the headway that he was making, the struggle for existence seemed keener than ever, and but for the kindness of friends he and his family would frequently have actually wanted for food. A timely advance of one hundred francs obtained for him from the Minister of Fine Arts, together with a commission from the State, for which he was paid the sum of eighteen hundred francs, were for some time the only relief he obtained from his embarrassments. That he was not particular as to how he earned his daily bread is apparent from the fact

that he did not despise an order for a shop sign for a midwife, for which he was paid the miserable amount of thirty francs.

The year 1848 was not an encouraging one for a painter who was standing on the threshold of his career. The whole of Europe was seething with revolution. A repetition of the fearful year of 1792 was everywhere expected. The struggle betwixt reaction and property on the one hand, and lawlessness and revolution on the other, was being waged with grim determination. The issue was for long in the balance. One never knew from one day to another what was going to happen. In such a deplorable state of affairs men's minds were running on politics and wars rather than upon art. Millet amongst the rest was called upon to shoulder the musket, and it can be easily imagined with what reluctance he did so.

Paris, the great centre of art, had yet not afforded him much encouragement. Life was dear in the big city, and surrounded on all sides by bricks and mortar he was not free to go out into the fields and study the objects which were uppermost in his mind. He resolved to escape from it, and once having put the plan into execution he never returned.

V

Millet in his Maturity

THE Barbizon of 1850 was a very different place from the Barbizon of to-day. The world fame of the men who passed a quiet and strenuous existence in the little village has transformed it into a tourist resort, with restaurants and cafés, the stopping-places for waggonettes which in summer bring their daily load of sightseers, eager to see the homes of the painters whose names are now household words.

It would have been well-nigh impossible for the little band to have chosen a more suitable spot for their labours. Rousseau and Millet, much as they were drawn towards each other by the tie of a sympathetic disposition and by their common interest in art, yet were widely dissimilar from one another in their outlook upon art and their methods of worship at the common shrine. Rousseau—one can see it from every picture he painted—loved with all the yearning of a passionate and restless temperament the inanimate in Nature. Observe with what fidelity he draws his trees, with what caressing tenderness his clouds and skies are treated; solitude appealed to him above all things, and if here and there he was obliged to insert a few figures to complete his composition, one instinctively feels that he would rather have substituted a group of cattle or a flock of sheep. In the glades of the forest, far from the busy haunts of men, with the glorious sunlight penetrating from above, the breeze moaning through the branches, he was happy. A wild and turbulent temperament such as his not in-

frequently discovers exquisite enjoyment amidst such perfect tranquillity.

Barbizon, situated on the fringe of the great forest of Fontainebleau, therefore, permitted Rousseau to come into daily contact with the scenes which so appealed to him.

Millet, on the other hand, was absorbed in the peasant. The man who tilled the soil and raised the produce humanity requires for its subsistence by the sweat of his brow; the manifold duties of the labourer, his life and sorrows, appealed to him with irresistible force. An unpeopled track of wild and uncultivated land would not call forth any emotion in him, no matter how sublime the scenery might be. The life of the village, spreading itself into the vast and fertile plain behind, held him absorbed; a peasant himself and living amongst the people he so loved, he was in a position to bring before an unthinking world the poignant monotony of their useful lives.

Upon their first arrival at Barbizon, the two artists put up at a small inn, working all day in a tiny place they had rented from some peasants and fitted up as a studio. The inconveniences of this arrangement were soon apparent, and shortly afterwards Millet took a small house which was destined to be his abode for the remainder of his life; an old barn in the immediate vicinity meanwhile provided him with an excellent studio.

From this period onward we must date the greatest productions of the master, the works which have induced more thought than those of any other peasant painter. A peasant among peasants, his life was of the most rigid simplicity. Behind his little abode a large garden stretched away almost to the fringe of the forest itself, and here he was accustomed to work every morning, growing a portion of the food necessary

to the sustenance of his family. The afternoon he devoted to painting, whilst the evening was given over to intercourse with his little circle of friends. The simplicity and tranquillity of his life aroused the whole of his powers to action, and surrounded with everything he valued in life he was supremely happy.

The country around Barbizon appealed to him irresistibly. The timber-studded plains, the gently undulating, highly cultivated fields, presented a strange contrast to the wild and rugged country amidst which he had spent his childhood, and no doubt conduced to the development of a more refined and contemplative style than he would otherwise have acquired. Upon his few visits to his native country he appears to have been more impressed than ever with its austerity, and the drawings which these journeys called forth bore ample evidence of this feeling in him.

Lack of the necessary funds to carry on even his simple ménage was ever the bane of Millet's life. On many occasions Sensier, his intimate friend and afterwards his biographer, informs us he dissuaded him from suicide.

The sums that he owed, small though they were, rendered him in constant fear of the brokers. With creditors so importunate in their demands for satisfaction, and with the constant lack of recognition, which was his lot, it is astonishing that Millet achieved so much. He was relieved more than once by the kind-hearted and ever faithful Rousseau, who when his friend was sorest pressed found some delicately hidden means to relieve him. It was he who acquired for 4000 francs the wonderful "Peasant grafting a Tree," when the picture failed to find a purchaser; and in order that Millet should not be aware of his generosity, he made the offer in the name of an imaginary American. This sort of goodness he repeated more

PLATE VII.—THE SAWYERS

(In the South Kensington Museum)

Very few of Millet's works can rival this superb picture in vigour of handling and magic of line. He has succeeded in infusing an enormous amount of energy into the two figures, without sacrificing refinement. The absolute stillness of the wood beyond is unbroken, save by the monotonous hacking of the wood-cutter, who, axe in hand, is making a determined onslaught upon a venerable tree. As an example of Millet's powers as a painter it would be hard to beat, and in it he has preserved those rare qualities of freedom and rhythm of line we find in his best drawings.

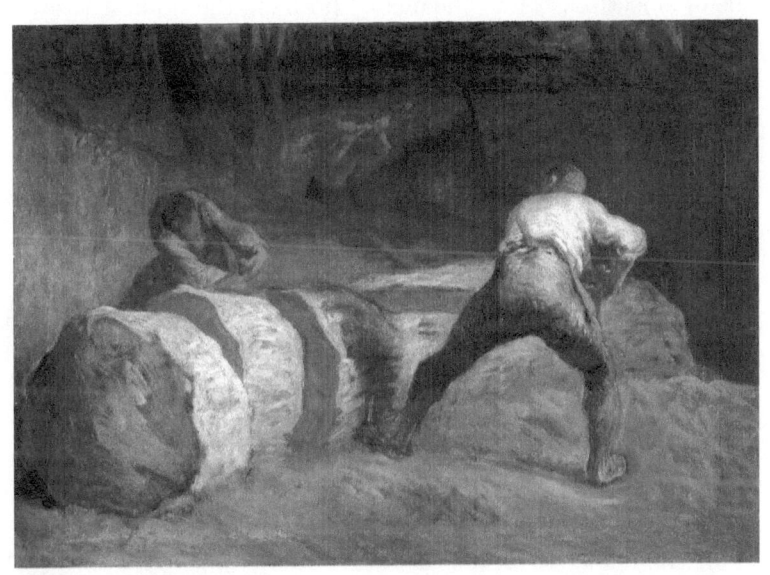

than once, and it redounds still more to his credit when we remember that Rousseau himself was not infrequently in pecuniary difficulties.

A constant succession of important works made their appearance during the first ten years Millet spent at Barbizon. The first was the well-known "Sower," which has ever been one of the most popular of his pictures. Then came the far finer "Peasants going to Work," which for many years was in an English Collection. The "Gleaners," perhaps the noblest canvas the master ever painted, dates from 1857, in which year it was seen at the Salon; the celebrated "Angelus" followed it two years later. The prices which Millet obtained for this series of remarkable works was fantastically small. The "Gleaners" brought him a paltry 2000 francs, whilst he accounted himself lucky to encounter an amateur who gave him the same sum for the small "Woman feeding Fowls." The "Angelus," which was never exhibited, was sold in the year it was painted to a Monsieur Feydeau, an architect, for 1800 francs. It then passed through several hands before the late Monsieur Secrétan competed up to 160,000 francs before he became possessed of the prize at the John Wilson sale.

The purchase, however, proved a sound investment, for upon the dispersal of his collection it was knocked down for 553,000 francs to a Monsieur Proust, acting on behalf of the French Government. The latter, however, when they gave the commission to buy the picture, had no idea that such a high value would be placed upon it, and consequently refused to ratify the sale; a syndicate now came upon the scene, who took it to America. The price, however, proved greater than even the millionaires of the States were prepared to give, and the canvas again returned to France, where it found a resting-

place in the collection of Monsieur Chauchard, who paid the enormous sum of 800,000 francs for its possession.

In 1859 Millet sent two works to the Salon, a "Woman grazing her Cow," and "Death and the Woodman." The latter, one of the most philosophical of Millet's pictures, which to-day is the principal attraction of the Jacobsen Museum at Copenhagen, was rejected. Disappointments of this kind came with such systematic regularity to the painter that he must have become proof against them. He always had bitter enemies amongst the critics, who never failed to pour abuse upon his method and his subjects. Even a number of his fellow artists joined in the chorus of disapproval. But the vehemence with which he was attacked was striking evidence of the impression he was making and the inward sense of his own powers; and the fact that he was working out his destiny according to the dictates of his own genius supported him against this outpouring of prejudice and malice. The social side of life appealed to him more strongly as the years rolled on, and the murmurings which had been heard in 1859 as to the socialistic tendencies of "Death and the Woodman" swelled to a roar when the stupendous "Man with the Hoe" was exhibited fourteen years later. The latter, one of the most virile studies of depraved humanity which the world has ever seen, has always been a favourite with social reformers, and has inspired one remarkable poem. Even his most implacable critics were disarmed before this canvas; its power was magnetic; it was an inspiration, soul moving and trenchant.

His financial difficulties never completely dispersed. At one time, in order to insure himself a little tranquillity, he made a contract with two speculators, whereby they were to become possessors of all the work he produced for three years, in con-

sideration of their assuring him a thousand francs a month. A great number of Millet's finest productions passed thus through their hands, including the "Return from the Fields" and the "Man with the Hoe." The partners were not long in quarrelling, and after a lawsuit had been fought, Millet was left in the hands of a man who frequently would not or could not pay him in ready money, and whose bills he was frequently forced to discount at considerable loss.

One little gleam of sunshine rendered his later days happy. This was a commission from a Colmar banker, Monsieur Thomas by name, who required four allegorical compositions representing the Seasons, to decorate his rooms. The artist was overjoyed by this piece of good fortune, and immediately commenced a most conscientious study of such mural decoration as was within reach, in order that he might do full justice to his patron. He paid frequent visits to Fontainebleau and the Louvre, and even desired a friend to inquire if he could not obtain reproductions of the frescoes at Herculaneum and Pompeii. In spite of all this elaborate preparation, the subjects were not such as appealed to his genius, and in spite of them being well and soundly painted, we are told that they presented no features which called for special comment.

He found, however, a much more genial occupation in accomplishing a series of drawings ordered by a Monsieur Gavet, who paid the artist 1000, 700, and 450 francs each, according to their size. He made altogether ninety-five drawings in this way, and it is said that this gentleman had in his possession the finest work in black and white and water-colour the artist ever executed.

Towards the latter end of his life the death of dear relatives and friends cast a sorrowful gloom over him. Amongst the

latter Rousseau, who expired in his presence on the 22nd of December 1867, was perhaps the loss which seemed to him hardest to bear. A staunch and trusty friend, who was to be relied upon when his prospects seemed the most hopeless, he had been one of the very few who had appreciated Millet's talents at their full worth, and who, moreover, scanty as his own means were, was ever ready to stretch out his hand to assist his struggling friend.

Shortly afterwards Millet paid a visit to his patron, Herr Hartmann, at Münster, and from here he went for a short time into Switzerland. Upon his return he devoted himself with great earnestness to work, and achieved a certain success at the Salons with his exhibits. The outbreak of the war with Germany caused him to migrate with his family to Cherbourg, where he thought he might continue to work, removed as far as possible from the scenes of carnage and struggle which were going on farther east. Transported once more amongst the scenes of his childhood, he felt an increased impetus to production, and when he returned to Barbizon late in 1871, he brought with him a number of canvases of the highest quality; conspicuous amongst them was the wonderful "Gréville Church," now in the Louvre.

The anxieties of his troublous life were, however, beginning to show their effect upon his constitution; a persistent cough developed, and although an amelioration would occasionally occur, it was always succeeded by a worse condition than before. His health suffered a general decline, and he finally breathed his last on the 20th of January 1875. He was buried in the little cemetery of Chailly, beside his friend Rousseau, amidst the scenery they both loved so well.

PLATE VIII.—THE SHEEP-FOLD
(In the Glasgow Corporation Art Galleries)

The poetry of moonlight has never been better realised than by Millet. The lonely watch of the shepherd, the huddling together of the sheep, the dreary mystical plain stretching away to the horizon, losing itself finally in the vaporous atmosphere of the chilly night, are all rendered with astonishing fidelity. It is in such works as these that the master reveals his sympathy with the solitude of many phases of peasant life.

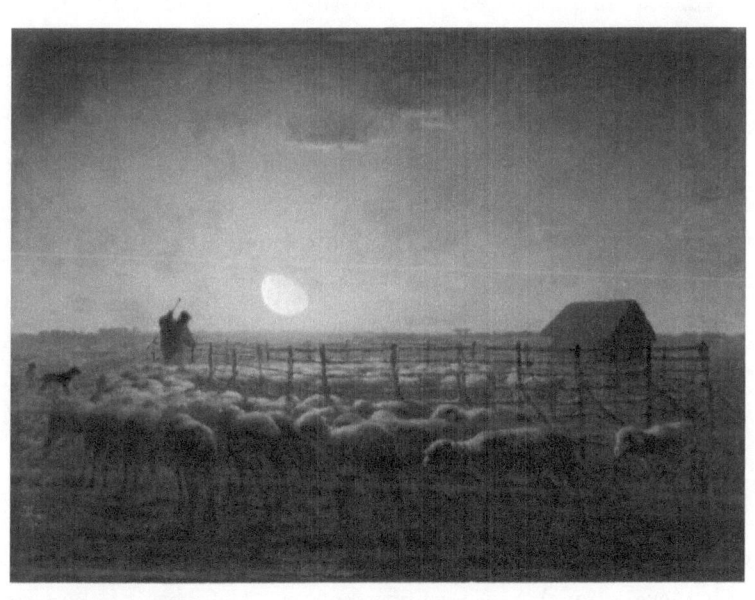

VI

The Man and his Art

MILLET is an instance of an artist working out his own destiny, impelled by irresistible genius, in the teeth of seemingly insurmountable obstacles. He started life with enormous disadvantages; without friends in influential circles to spread his fame or plead his cause; without money to enable him to outlive and triumph over the ignorant fanaticism of critics and artists, so soaked in the conventionalised art of their time that they had not perception enough to appreciate the full meaning of that naturalistic movement, which was finally to sweep away the quasi-classic art they boasted of with such bombastic effusion. The path was hard and thorny, and his triumph was not finally consummated until after his death. He himself found his only satisfaction in the fact that he had lived his life according to the dictates of his genius, and had achieved the maximum of which he was capable.

Millet and our own Cotman were somewhat kindred spirits; there is much more affinity between the work of the two men than is apparent to any one who has not closely studied them. The marvellous "Breaking the Clod," now happily permanently housed at the British Museum, betrays the same tremendous conception and broad outlook which characterises many a drawing of Millet's. Both highly strung to a painful extent, they were each conscious of their inability to curb the power which prescribed a certain course for them, and in spite of pecuniary difficulties and unpopularity, an inevitable result

of their intense originality, they pursued a steady course to the end of their lives.

The socialistic doctrines which have been read into the work of Millet are rather the outcome of the world's uneasy conscience being brought face to face with a crushing indictment of existing conditions, than of any design on the artist's part to further the cause of a political propaganda by means of his art. This somewhat extravagant reading into his art has certainly been carried to excess. Particularly has such been the case in America, where a large number of his finest works are at present to be found, curiously enough in the hands of enormously wealthy people, who are frequently perhaps the least able to understand the real meaning of his message.

Coming from a peasant stock, his sympathies were always with the peasant; it was the only class he understood or cared for. He lived as one of them, and shared to a large extent in their labour. He has been designated, not inappropriately, the philosopher in sabots. Rightly or wrongly he has come to be looked upon as one of the high priests of communistic doctrines. Few pictures have been so anathematised as the "Man with the Hoe," and perhaps none have done more to inculcate sympathy with the degradation of the lower orders of the human race. The revolting brutality and vacancy of that face haunts the imagination. Is it possible that fellow-creatures so utterly debased by toil and neglect exist? Millet dispels any doubt upon the question by bequeathing to humanity this trenchant portrait. By no means limited to Barbizon or France, these poor creatures exist in every country, and curiously enough are considered an essential element in each country's development.

This poignantly human note is observable in almost every

work Millet wrought; his passionate sympathy with his fellow-man is the keynote of his art. The wood-cutter in his arduous toil, the shepherd in his solitariness, the labourer turning the soil with unvarying and laborious monotony, the mother caring for her children—all carry the same message for him of that strange and incomprehensible mingling of joy and sadness we call life. Like many great minds before and since his time, our artist found the greatest joy in life in a placid and never changing melancholy. But the peasants he chose knew nothing of the sadness he saw in them. Completely inured to their toil, and subdued by it, with no refining or uplifting influence to stimulate them, they knew nothing, aspired to nothing beyond what they were; it was left to Millet to supply the "might have been." He saw the inky blackness of the mind of the "Man with the Hoe," the pathetic inequality between the mounted farmer directing the safe storage of his crop, and the stooping figures of the "Gleaners" eager to scrape up the miserable crumbs which had fallen from the rich man's table. He traced the lives of these simple folk until we arrive at the grim and gaunt figure of Death, who, as he grasps the woodman by the shoulder, reminds him that his course is finished and that he, in common with all his fellow-men, must enter the great unknown land from which there is no return. It is a sad and melancholy art, vibrating with purity and truth, the outpouring of a great soul yearning to express itself to the utmost of its power. The mind and character of the man can be read in every line and in every touch of the brush. His drawings and etchings are even more searching in their virility than his pictures. There is a spontaneousness about them we search for in vain in his work in oil and pastel. In black and white his intensely emotional mind found a swift method of expression;

in the laboriousness of oil painting he was fettered with the complications of the medium. It can be fairly said that only in one or two paintings—a notable example can be cited in the wondrous "Sawyers" at South Kensington—does he rise to the height of a great painter. Millet was a poet, a philosopher, a great thinker, and the means he chose for expressing himself were those which were best fitted to his purpose. His predilections in art were concentrated upon the greatest, and consequently the men who appealed to him were the thinkers of the ages. Mantegna and Correggio, Michel Angelo and the mighty Greeks, these were the masters who left their impress upon his mind and art.

The influence of so sincere and profound an artist has necessarily been profound. He has moulded men who have achieved world-wide fame; Segantini, for example, would never have risen to the heights he did had the example of Millet not been ever before him. There have been many who, without possessing his genius, have endeavoured to follow in his footsteps, but successfully as his imitators have sometimes caught his style, their productions can never live alongside his, because they lack the real ring of sincerity.